FINDINGKALMAN

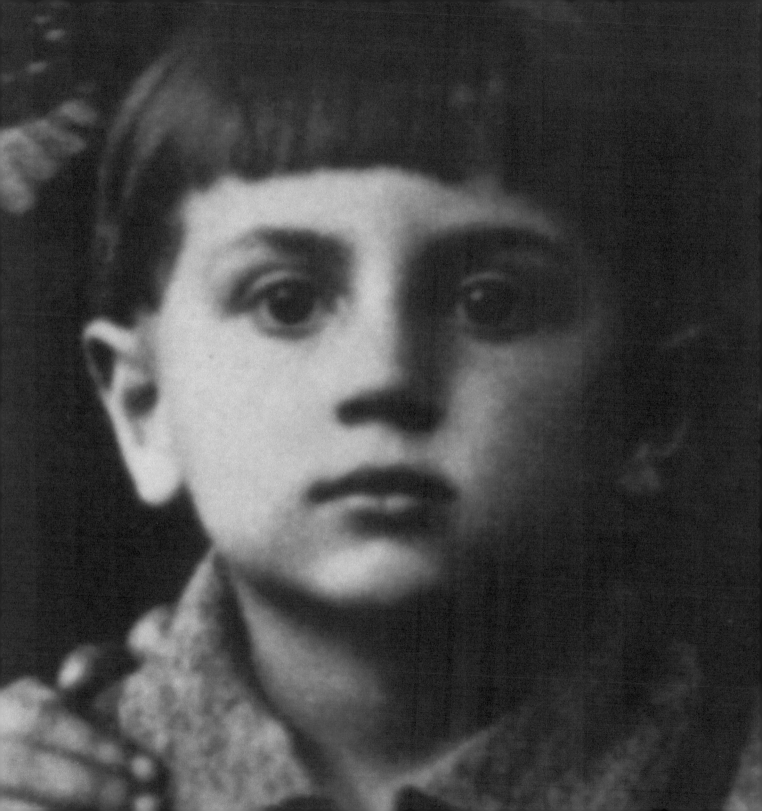

by Roz Jacobs

and # FINDINGKALMAN

Anna Huberman Jacobs

ABINGDON SQUARE PUBLISHING

New York

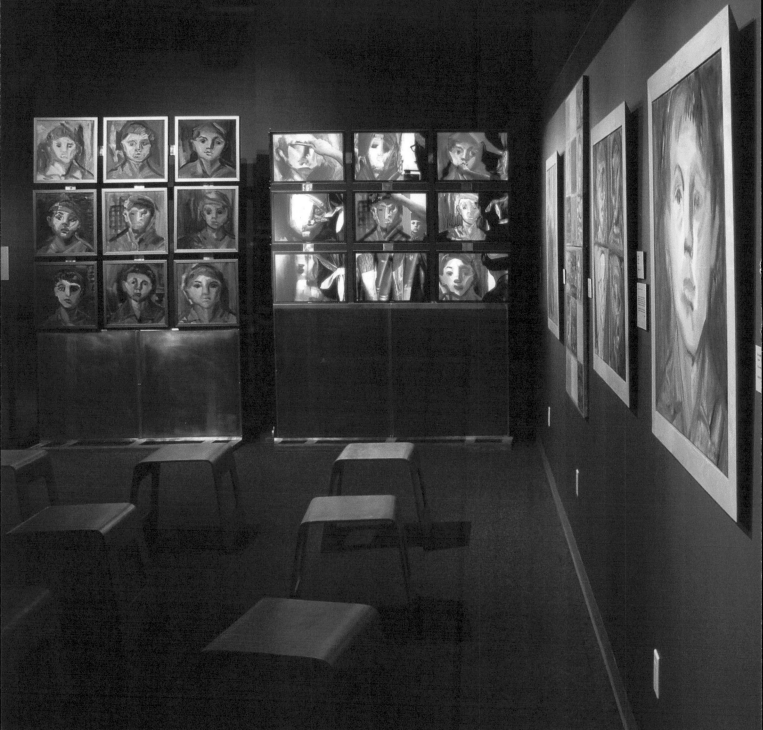

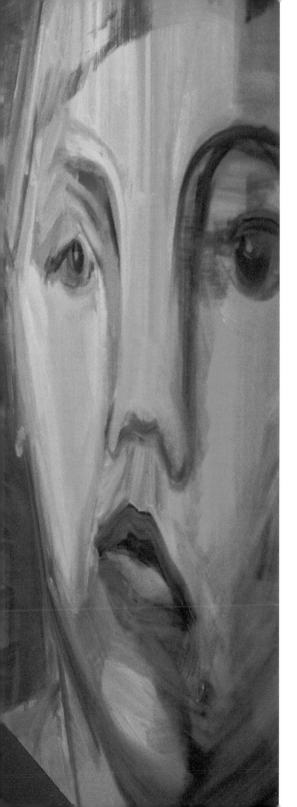

In 1979, I met Roz and her parents. Anna and Jack Jacobs, both Holocaust survivors, had not only rebuilt their lives from the ruins of the war, they had thrived. I became almost desperate to know their stories—how they survived and how they were able to live rich, happy lives after so much loss and trauma. They showed a human resiliency that I had never experienced before and that I wanted to share. Many years later, Roz and I found a way with "The Memory Project."

The core of The Memory Project is a multimedia art installation. Nine painted portraits stand in combination with a similar arrangement of video screens. On the screens, viewers watch the process of Roz painting each portrait of Kalman, her mother's beloved younger brother who vanished during World War II. With each of Roz's brushstrokes, Anna shares the experiences she and Kalman had as Jewish children in Nazi-occupied Poland. The Memory Project reflects on feelings of loss, love, and memory.

In 2008, as the project grew, we formed The Memory Project Productions, a not-for-profit organization committed to using Holocaust survivor's stories and art to open people's hearts and minds. The exhibition, the award-winning documentary *Finding Kalman*, and educational programs are traveling to museums, theaters and schools around the world.

This book, *Finding Kalman*, is the latest piece of the project. In it, Roz's words are printed in blue and her mother's are in brown. I hope that this book touches your hearts as their stories have touched mine.

—Laurie Weisman, Executive Director, Memory Project Productions

FINDINGKALMAN

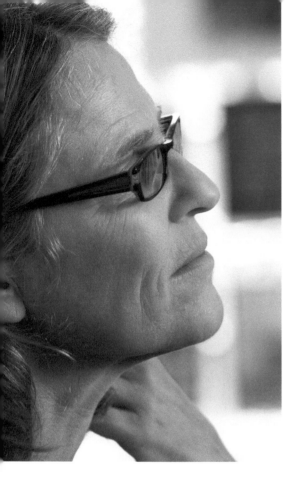

ROZ JACOBS

I don't remember the first time I heard the name of my mother's brother. Kalman. My uncle. In Hebrew, "Dod;" in Yiddish, "Feta;" in Polish "Vuiek."

These words seem strange when connected to a picture of a boy. They are adult terms, and in the memories I have constructed of Kalman, he has never grown up. Kalman is forever five, the boy in the family portrait who stares at the camera with a defiant gleam in his eye. Kalman is forever 10, standing next to his big sister in cap and coat, the slightest hint of a grin teasing us to imagine what he was thinking at the time. Kalman is forever 14, waving good-bye to my mother as he leaves her side for the last time.

It is possible that someone, somewhere, has a memory of a different Kalman. Kalman at 22, a strong, muscled man intently rebuilding his life from the ruins of a war. Kalman at 60, surrounded by a flock of devoted children and grandchildren. A family that doesn't know my name, that doesn't know the names of my brothers and their children, even though the same blood, the same history, flows through us.

The possibility of those memories, however, is remote. I know this. I have seen it in my mother's eyes when she says, "I know for sure that if he would have been alive, somehow, we would have found each other. And we didn't." She knows with the certainty of a sister who shared an undeniable bond with her baby brother.

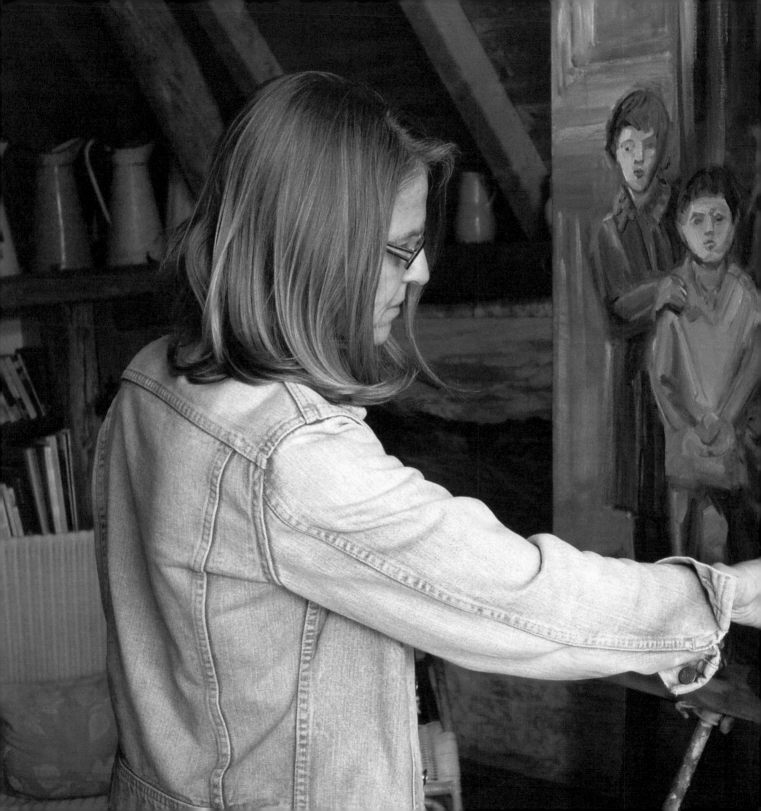

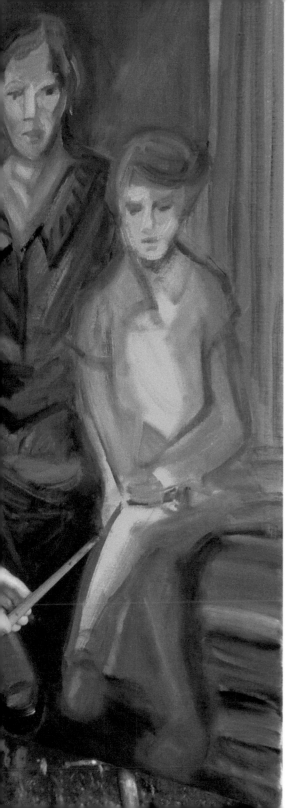

So even though I grew up fantasizing about the day when I would reunite my mother and her little brother, to us Kalman remains forever a boy. His adult memories have been stripped from our family—through separation, through destruction, through death.

The painting process is full of destruction in a different way. As I work on my art, every time I add new paint to the canvas, I am destroying the image that existed before. And just as my paintings have to survive a series of destructions before they can live in their current forms, so our family has survived a series of destructions to live in our current form, vibrant in color, rich in love, and carrying forward the memory of a boy, Kalman, who will never be left behind.

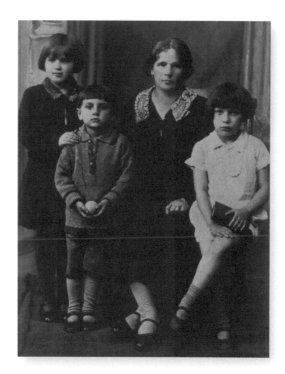

3

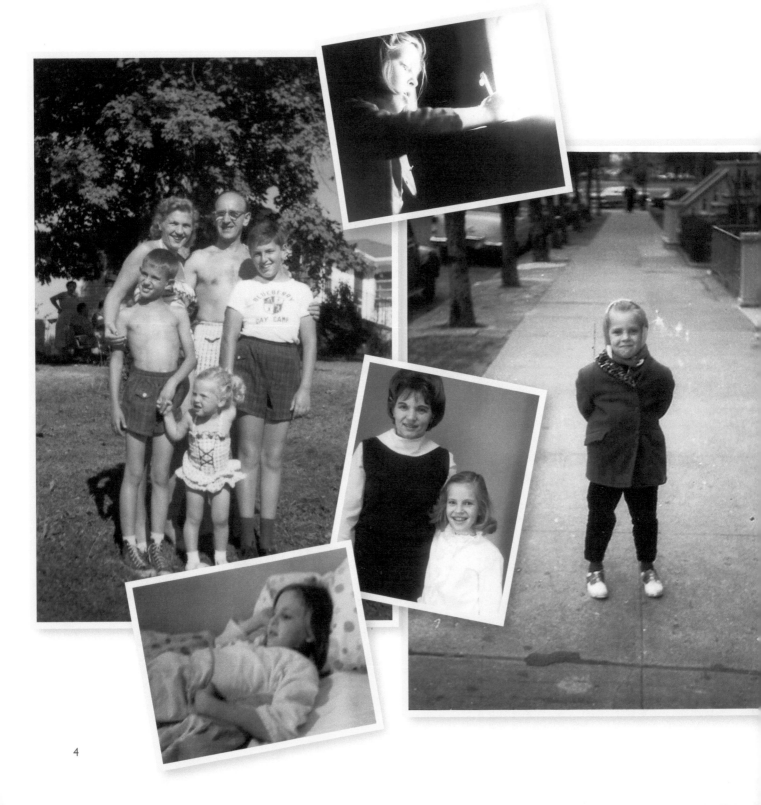

My mother—Anna, Andzia, Angie, Chanah, Momma J—is a natural-born storyteller. But when I was a child, she didn't talk much about the biggest story of her life—surviving the Nazi persecution of Jews—because her other natural-born talent is mothering. And how do you share that story with the children you have delivered into this world? How do you, as a mother whose every instinct is to protect your children until your last dying breath, explain that the world can be a terrible, dark place, and that you know this because you have seen it firsthand?

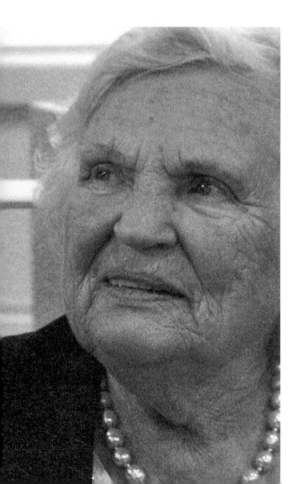

ANNA HUBERMAN JACOBS

I had to wake her up. I woke her with a kiss. Sometimes when she was so sleepy and she didn't want to wake up, then I talked to her. I told her a story and she always wanted more. Always wanted more stories. Always curious. Always wanted to know the details, even when she was very young. "What you need this for? What is that?" And sometimes there were things that I didn't want to answer.

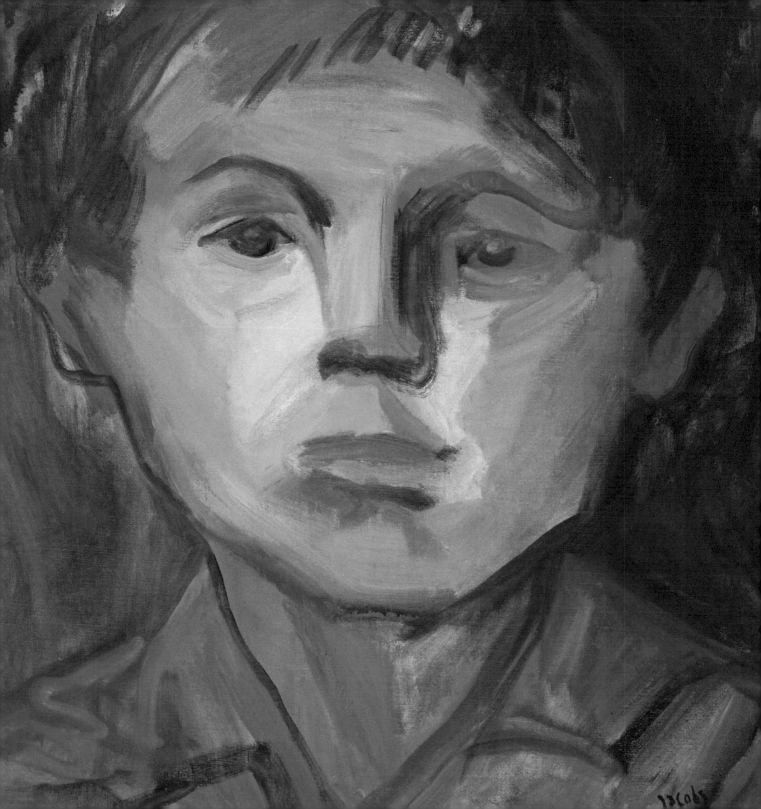

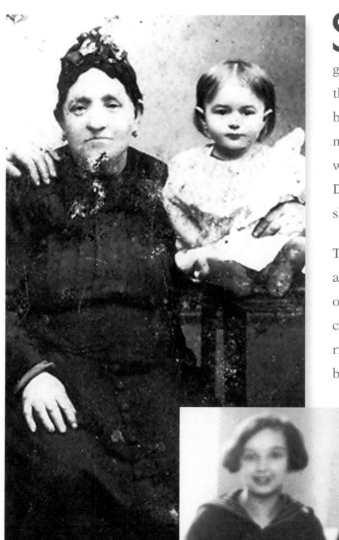

Anna's cousin Zena with their great-grandmother Devorah,
Anna's sister Henia with their mother Roisa.

So as a young child, I first met Kalman, and my mother's big sister, Henia; her parents, Roisa and Ephraim; her grandmother Esther and her great-grandmother Devorah, through my mother's happy tales. She would crawl into bed to wake me up before school, always gently caressing my face, and I'd gobble up her stories of life before the war, when she was a little girl in Poland. Like the story of Devorah, who wanted to bless everyone in the family before she died, so she waited until they all arrived at her deathbed.

Those stories have a physical connection for me, as tangible as the paint that sweeps across my canvases. When I think of them, I remember how soft the skin was on my mother's chest. I remember her voice, and the happiness I heard ringing through it. How eager she was to talk about her brother. Kalman, a "very bright boy, very bright."

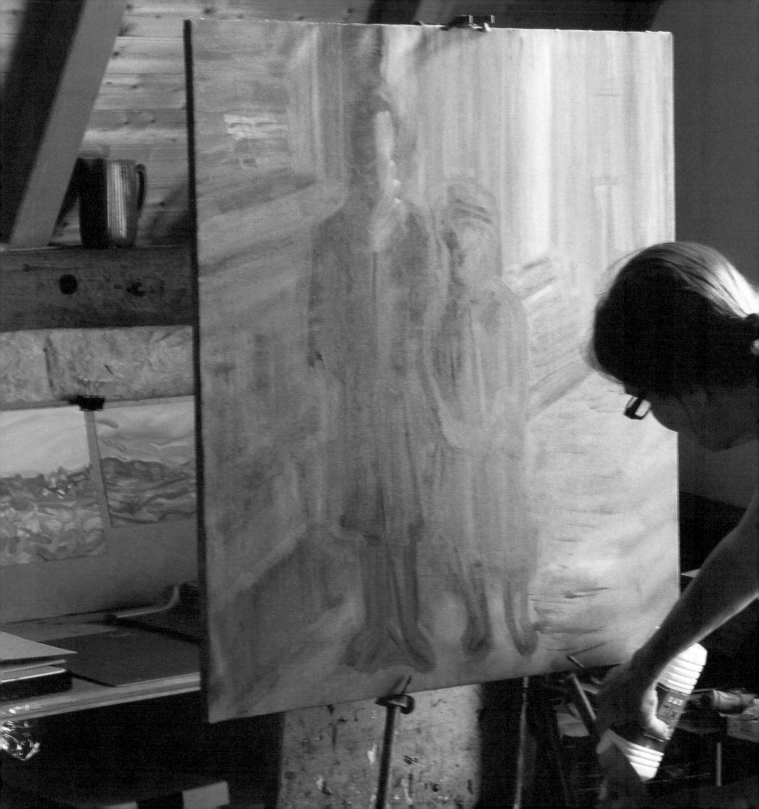

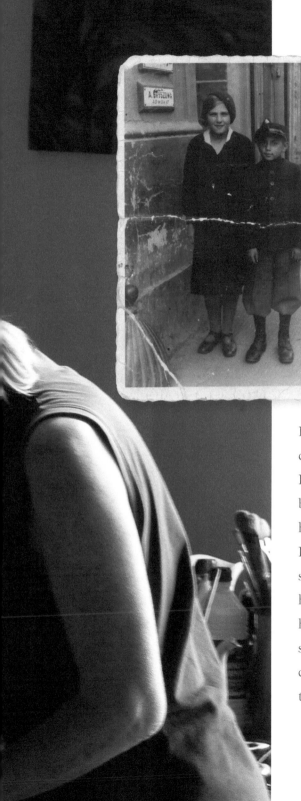

Through my mother's stories, Kalman became a real boy to me. No longer just a face in an old family photo. He acted up at home. He talked back to his teachers. He tried my mother's patience.

I was smart, but he was even smarter than me. He started to read the Polish newspaper when he was four years old. So a neighbor was always waiting Sunday on the porch with the newspaper. I think she didn't know how to read. She was waiting and she called, "Kamulek, Kamulek, come, read for me." She didn't have any children. He liked that she was proud of him, a young kid.

I loved him and I had a big responsibility because I was the middle child and wherever I went, I was supposed to take him with me. I didn't like it. So one Saturday, I went with some friends to the beach and he wanted to come with me. My mother said, "You have to take him," so I had no choice. One of his friends came and I was sitting on a blanket with my friends. Kalman went and was showing off to his friends with swimming. But he didn't know how to swim and he was starting to go under. Some people pulled him up and I was scared to death. I was so scared and angry and I said, "I'm not going to take him anymore." I was afraid because I could have lost him that time. He was lucky and I was lucky (even though I got punished).

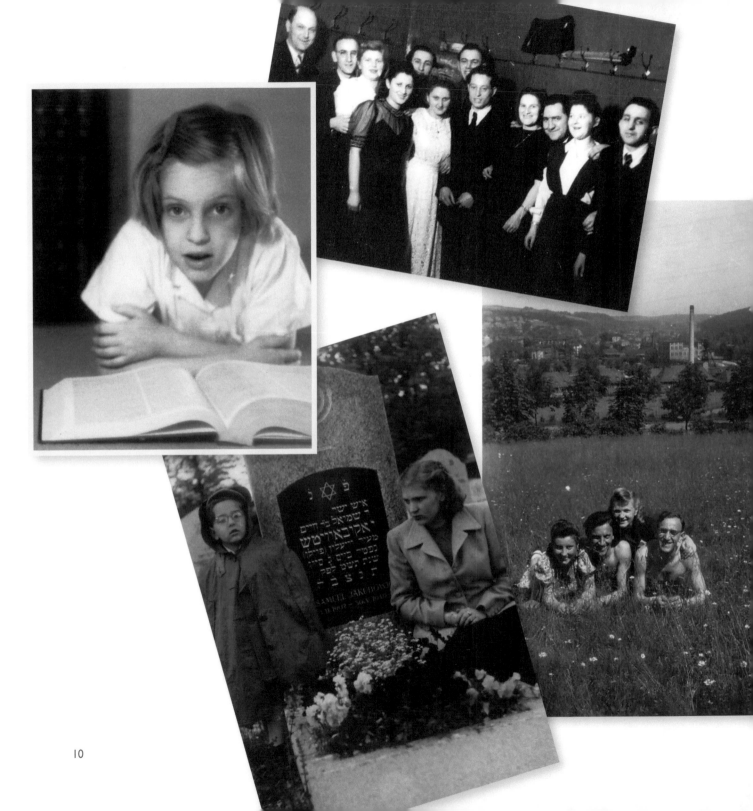

But as happy as her family stories seemed on the surface, I could tell there were deeper and different emotions hidden underneath. They confused and intrigued me, and my curiosity was insatiable. I wanted to know everything.

My mother would grow inexplicably sad sometimes. Why did her eyes well up when she lit the Sabbath candles? Why did she and her friends lapse into Yiddish when they got together? I remember playing under the table with my friend Mel while a half-dozen adults would sit with old photos talking about their hometown. In America, my father Jack was President of the Wielun Society—named for his small town in Poland. They were working on a memorial book, recalling old friends and storefronts, matching names to pictures. The words floated over our heads as we played our own games. I didn't know they were talking about people who'd been killed, trying to memorialize an entire culture that had been demolished.

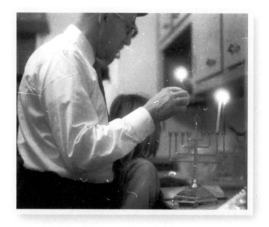

We didn't like to talk about it because we were always hurting and it was depressing. When you [Roz] got older, like 9 or 10, you got curious to know. "How come I don't have a grandfather or grandmother?" It was hard enough for us to understand why there were gassed to death…so how can you explain that to a child? But if you asked a question, I had to have an answer. I gave the truth without elaborating. They died in war…I gave short answers. Later on I had to give more answers. You were a very curious child and when you wanted something you went for it. So I told you about your grandfather who died of a heart attack after the war. Slowly, very slowly, I showed you pictures of my family. You, of all of my three children, were the most interested in what happened. To you it was like a very interesting story, like a movie.

Slowly, under the pressure of my relentless questioning, my mother began to share snippets of different stories—of being forced from her home in Wloclawek, Poland, of Kalman at 12 selling flints and cigarettes in the crowded Warsaw ghetto to help the family buy food. She was no longer just the mother who woke me with kisses, endlessly cajoled my brother Fred to eat his dinner, and loved having Sunday dinners at Four Brothers diner. She was a tough, brave girl in an unbelievable story of survival. And her brother was her constant companion. A pair of children, determined to escape with very few resources, just their own determination and wits.

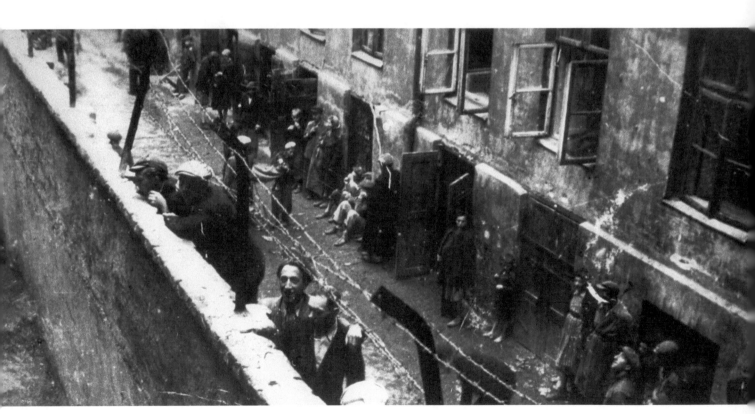

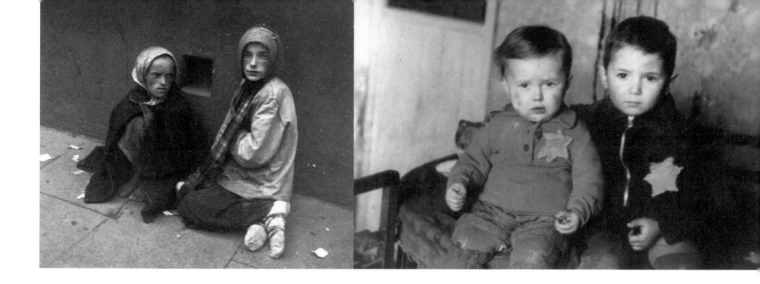

The Warsaw ghetto was a terrible place to be. First, there was a terrible hunger. Even if you still had a little money, there was not much that you can buy, maybe bread or a potato. They kept making the ghetto smaller and pushing in more people, so it became a bigger hunger and there was no place for people to live. We stayed with family, so we didn't have a problem with that. But you'd see children lying down on the street swollen. The following day, you saw them covered with newspapers. They were dead. You saw constantly people pushing wagons with bodies that they picked up from the street. As young as you were, you felt that it will happen to you some day.

I decided to leave the ghetto because anybody who was in the ghetto was getting coupons for food—very little food. What you got with those coupons was not enough for a week and you had to have it for a month. So I figured that if I leave the ghetto, my parents will have my coupon, and they will have something more than they have.

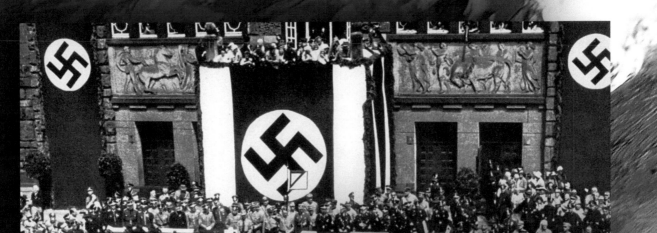
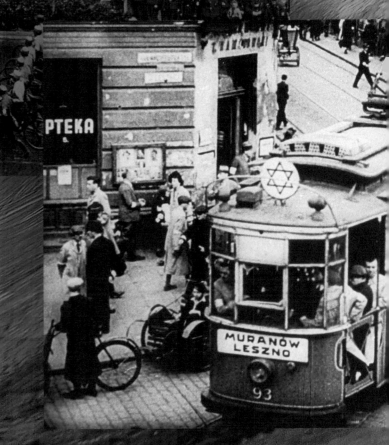

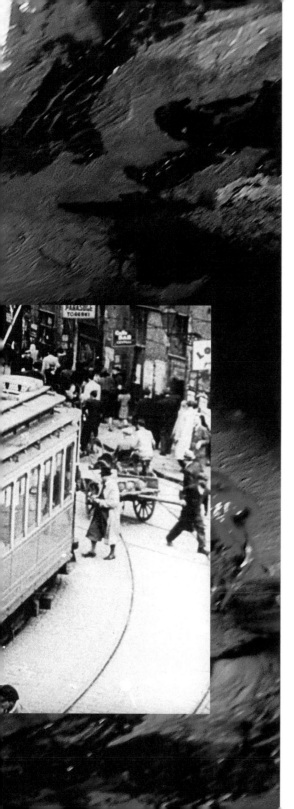

When my parents retired and moved from the Bronx to Florida in 1988 I helped them clean out their apartment. I found an old dictionary from when I was a child. The name Hitler was scratched out—the black mark on the page had been rubbed so hard that the page was actually torn. I suddenly remembered seeing that name as a child and taking a pen to rub the name out, thinking, "He doesn't deserve to be on a page." I wondered why didn't they kill him. Why did all of this pain and suffering happen? My child's mind saw that all the evil was in that one man, Hitler. That he alone caused all of the pain and suffering. I didn't understand the complexity and all the other people and governments who were also complicit. It brought me back to that moment in childhood when I felt like maybe I can erase this and it wouldn't have happened.

The first time when I wanted to escape from the ghetto, there was a train, like a trolley, that was going through the ghetto. So my brother and I went there. We passed through the ghetto, but before we went on the other side out of the ghetto, a German with a policeman, a Polish policeman, came onto that train and checked. They said, "All Jude out." Some kids went and some kids didn't go. My brother didn't go, he was sitting next to me. And then the policeman came over, or the German, I don't remember, and took him out. I wanted to see what happens. So I followed him. And that was on the border of ghetto and not ghetto.

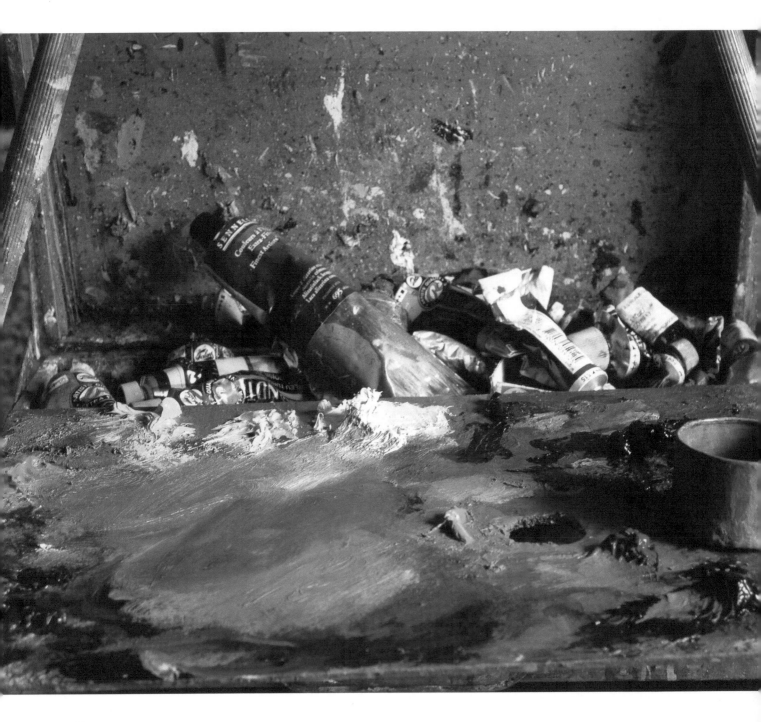

When I was 16—about the same age that my mother was when she escaped from the Warsaw ghetto, I began to truly feel my passion to be an artist. I remember seeing some Rembrandt drawings at the National Gallery in Washington, D.C. Something about the way his drawing captured the humanity of the figure spoke eloquently to me about life. It was like a direct line to a different century. Rembrandt was talking to me. It seemed like science fiction, but it felt very real. Through art, I could travel across time and space. I knew then and there that I wanted to be an artist.

Outside the trolley there was a booth with a German soldier and a Polish policeman. And he started to…the German started to hit my brother and I started to beg with him and talk to him. "Don't hit him, hit me because he's a little boy, he's a little child." And he started to get angry, but probably I touched him someplace because he threw us out of the booth and back to the ghetto. We were running and I lost one shoe. And I didn't have the shoe anymore. So this was the first time when I wanted to escape. I myself probably would be able to go through, but not with my brother—he looked Jewish, I didn't look Jewish. So I went back into the ghetto. We both were lucky, because the other children were taken back to this police station and then I don't know what happened to the other ones.

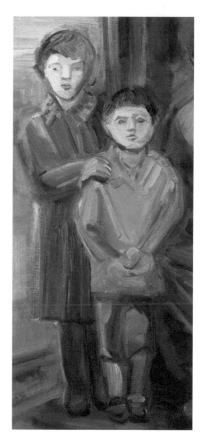

I was scared very much, but I couldn't do it—to go without my brother, not knowing what will happen to him. So I followed. Whatever will happen, will happen. You know things like that, you don't think, you do. That's what I did that time. I was very young that time. I think I was 15. I was lucky I followed him.

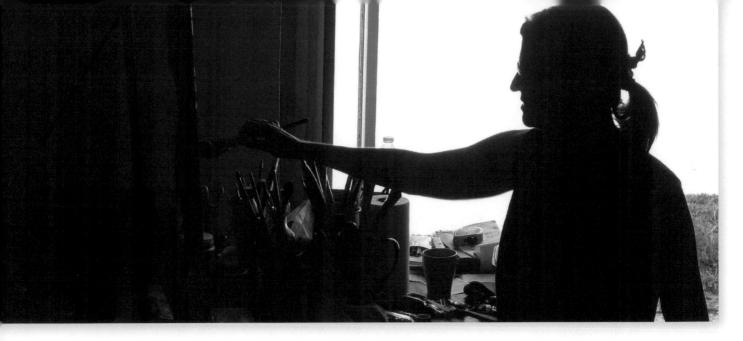

We don't always have control of how our memories flow in and out of our lives. Often, they come back in snippets—a word or a name can trigger an emotion that might bring you back to a scene from your past. I learned the story of my mother's survival—and her family's destruction—in these types of fragments. One day I would hear the story of how my great-grandmother Esther used homegrown herbal remedies to help neighbors who were sick. Another day, we'd go back in time to the early war years when Esther and Anna were forced out of their home by the Nazis, and Esther filled a pillowcase with grains and then gave all of her plants to a Gentile neighbor to take care of. I learned how Esther risked her life for her granddaughter, my mother. I love knowing these stories. I'm so grateful my mother has given me the gift of these stories. They allow me to connect to my family's life force, and to not remain fixated on their terrible deaths.

In the ghetto, I lived on Novolipie Street, 21. The Germans had built a wall to separate the Jewish section from the rest of Warsaw. That's what was called the ghetto. After maybe a year, my brother and uncle and my little cousin left the ghetto with some kind of travel permit. I decided I wanted to go, too. My mother had talked my sister out of leaving a few months earlier. She was afraid she'd never see my sister again. But now things were so bad my mother said to me, "Go my child. Save yourself." I had a plan. I was about 15 and my mother had some friends on the other side of the ghetto. So, in the evening some men pushed me up and over the wall and the friend caught me on the other side. She took me to the train station and bought a ticket for me and she left. I took that train to Ozarow, where I knew some people. We arrived there at four o'clock in the morning. I followed other people when they walked into town. By the time we came into town, it was light.

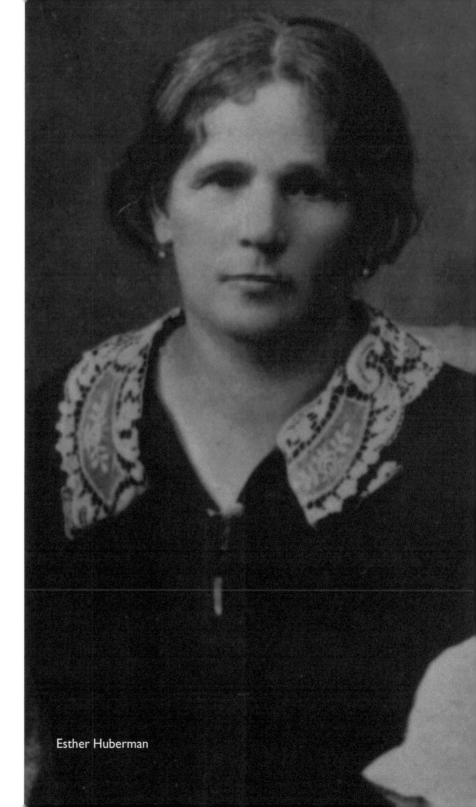

Esther Huberman

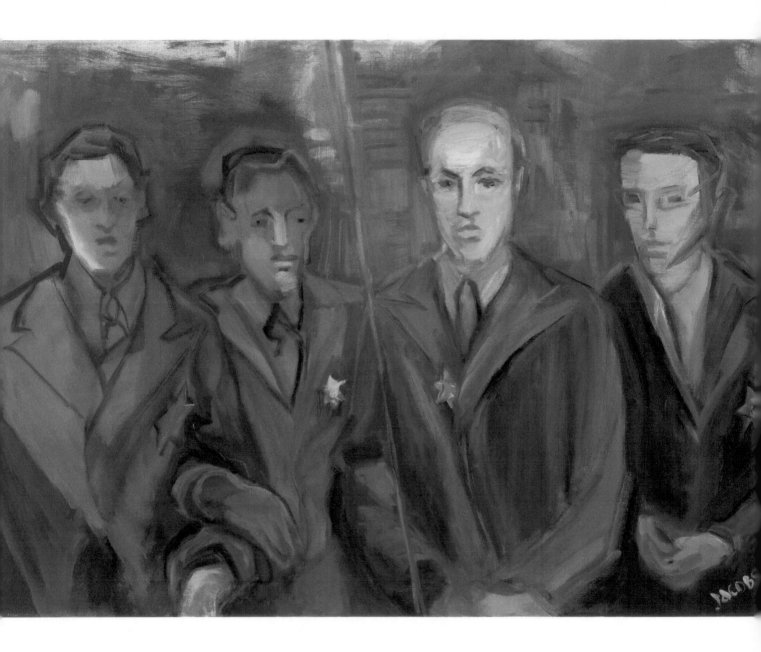

20

As my mother's memories filled my head with stories, images also filled my mind. I can't remember a time when I didn't have a pencil in my hand. As a child, it was a way for me to feel the world.

I can remember my mother working in the kitchen. My little bedroom was right next door. I was in heaven listening to her putter, or smelling her chicken soup as I drew pictures of our family and my cousins, uncles and aunts. When the family first came to America, we all lived together in one apartment. I loved being all together, especially with my cousin Nancy who was just a few months older than me. It broke my heart when my nuclear family moved out of our Washington Heights "collective" to the Bronx. Maybe that's why I loved drawing my extended family—to keep our connection tangible.

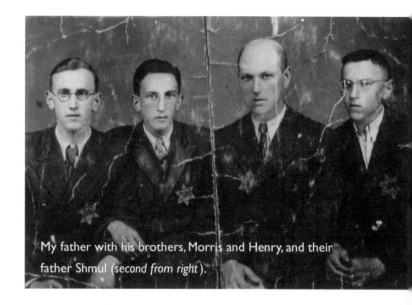
My father with his brothers, Morris and Henry, and their father Shmul (*second from right*).

Ozarow was a very small town. I don't know how many people lived there. In the center of the town, Jews were living. And around the town, non-Jews had their houses. The Nazis were occupying but they were not visible as much as other places. They had headquarters in a school or something, but it was more flexible. At that time you could go to the farmers to get some food. In Wloclawek we were wearing a star. And in Warsaw. You could not walk around in the ghetto without it. But in Ozarow, I don't think we wore anything. It was a little easier there.

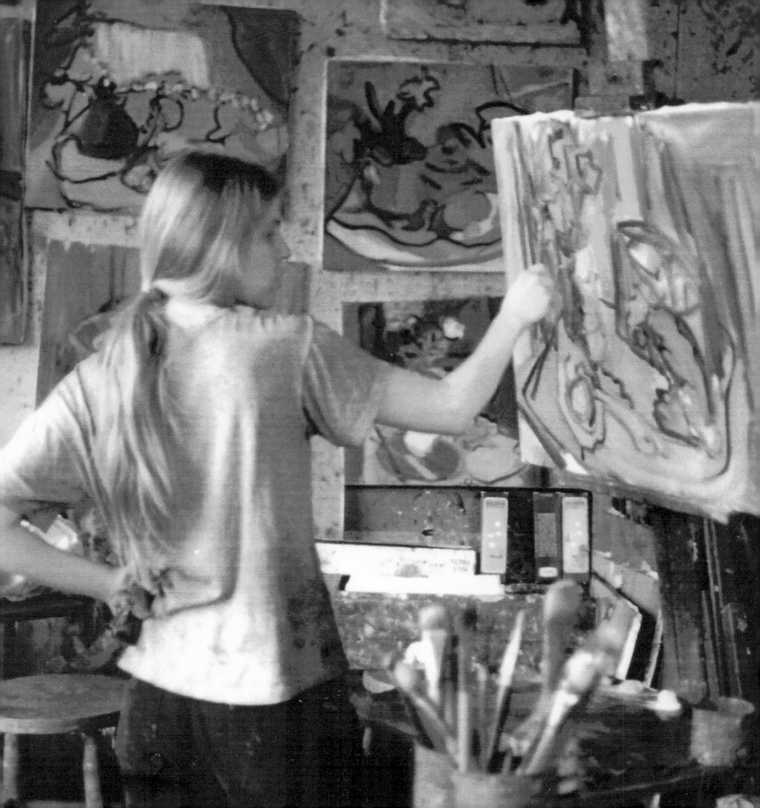

As my passion for art continued to grow, I dreamed of meeting a great teacher. That dream came true the summer I was 18 years old and had finished my first year of university. I was looking for a painting class in New York and I met Norman Raeben, who taught a small group of students in a studio in Carnegie Hall. I knew at once that I had happened upon a genius. I learned more in one day than I had learned in my life until then. After the next semester, I quit school and moved into a rundown tenement apartment in the East Village in New York City so I could study with Norman. I took classes six days a week in exchange for cleaning the studio each morning. My mother was furious with me. I was giving up a university education and scholarship to live in poverty and become an artist. This did not seem like a good life plan to her. I had no experience with the real poverty and struggles that she survived. I thought it was a perfect plan.

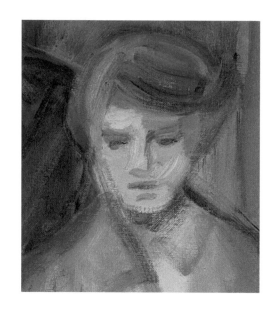

In the Warsaw ghetto, I worked for a few years as a babysitter. I saved every penny I earned. I sold a few things also. My mother's sister once gave me a box of perfumed soap as a gift. She worked in the ghetto in a factory that sold that soap. I didn't need that nice soap, so I sold it and had a little money and with that I rented a bed from a woman in Ozarow in her one-room apartment.

Then my brother arrived. He and my uncle and cousin had been arrested after they left the ghetto. But they let the kids out of jail after only a year and gave them a travel pass. When my brother got home and found out that I had escaped the ghetto, he came to me. We shared that little bed. But even there, we had no food. So he went to a farmer and got a job taking care of the cows. Just for food and lodging. He slept in a barn and for Shabbat he used to come to me.

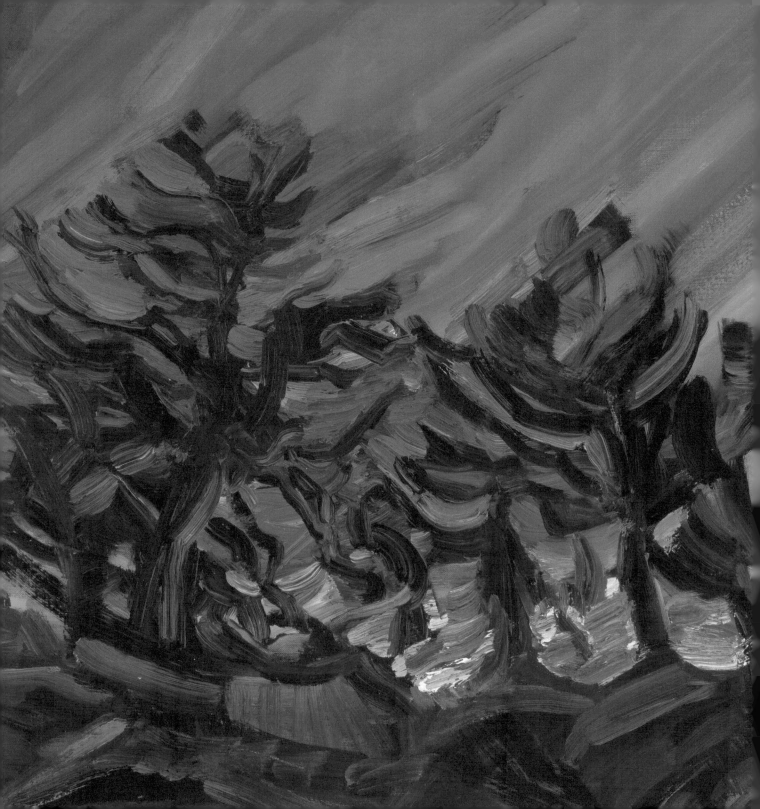

My teacher, Norman Raeben, used to say, "Art telescopes time." The past and the future are in the present moment that art is created. It's all contained in the painting. I began to gain understanding of that concept.

My first years of study were filled with learning about art, literature and philosophy. I had the luxury of time that my mother did not have when she was my age. I had the freedom to learn at my own pace. With Norman I learned how to "enter" the page as if it were infinite in space and time. I didn't feel like I was drawing on top of a piece of paper. Instead, I had the sense that the paper was space and I was drawing the subject out of that space—it was alive.

It was not easy to study art and support myself. But I felt so lucky and free. I never had the tremendous hardship that my parents experienced and I wanted to make the most of my opportunities.

It was like, I will say, four, five o'clock in the morning. They were knocking at the doors, like a German can knock. "*Jude* out, out, out!" They pushed everyone out to the market. There was a square in the middle of the town and there were hundreds and hundreds of people. My friend was with me and she said, "Let's hide!" and she did. She backed up into the house and hid. Somehow my feet were frozen and I couldn't move. That probably saved my life. Older people they sent back to the houses, so there remained only younger people. I found out that a few weeks later, all of those people who stayed behind were taken in a transport to Chelmno and gassed to death. So, by not hiding, I probably saved myself. That's what I mean when I say it was just luck that made some people survive. I was just lucky. Anyone who survived was lucky. It wasn't a matter of being smart.

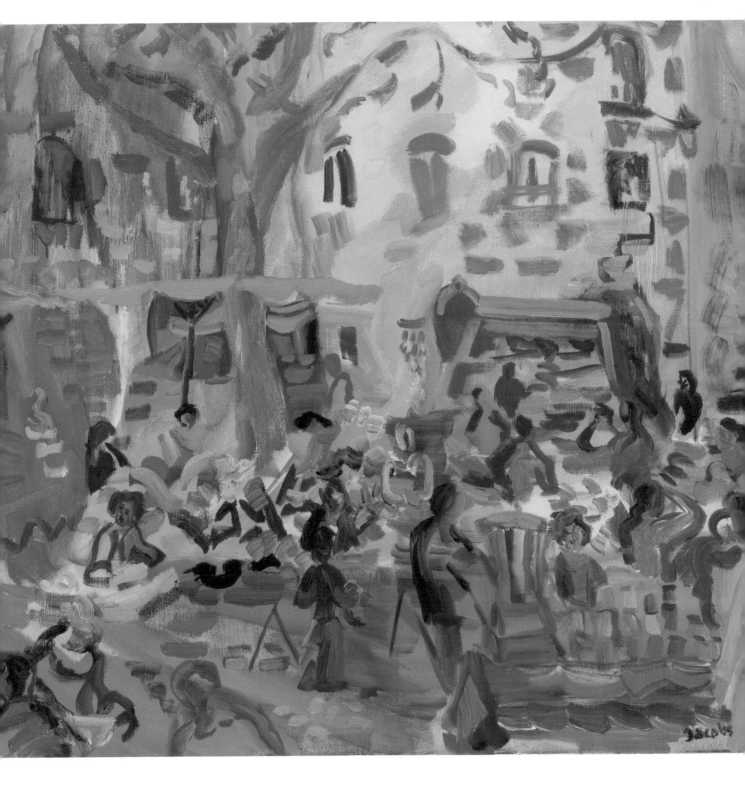

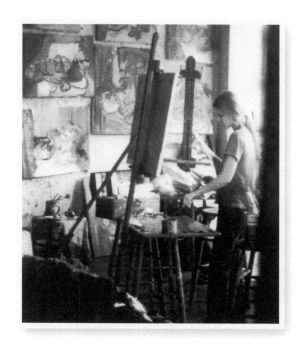

As a young art student, I traveled through Europe for five months, organizing my trip from museum to museum. I started in Amsterdam and backpacked my way south to Paris, Madrid, and Rome, stopping in many smaller cities in between. Spending time observing life on the streets and in the museums, I realized for the first time the different quality between the northern light of Holland and the warm light of the Mediterranean coast. You could see how Vermeer caught the cool northern light as it poured through his open window and why Impressionism and Fauvism thrived in southern France. I first painted landscapes in Europe—in Spain and later in France—where I felt connected to and inspired by those who painted before me.

From the market, they put us on army trucks and they shipped us to Skarzysko-Kamienno, which was a town with a factory of ammunition. We were making bullets and shells for the Germans. They had three factories: A, B, and C. I got into A, which was actually the best place to be. We were making shells. The other factories were putting powder in the shells. And that was a much, much harder job. The powder went on your lungs and your whole body was yellow. Your hair. Your clothes. Everything was burned yellow. So that was a bad place to be.

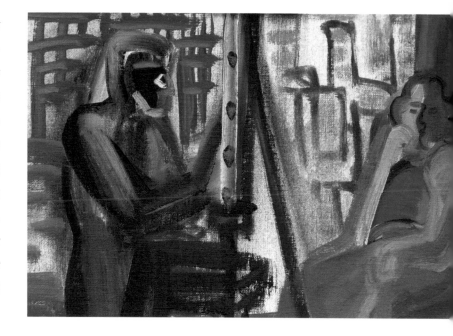

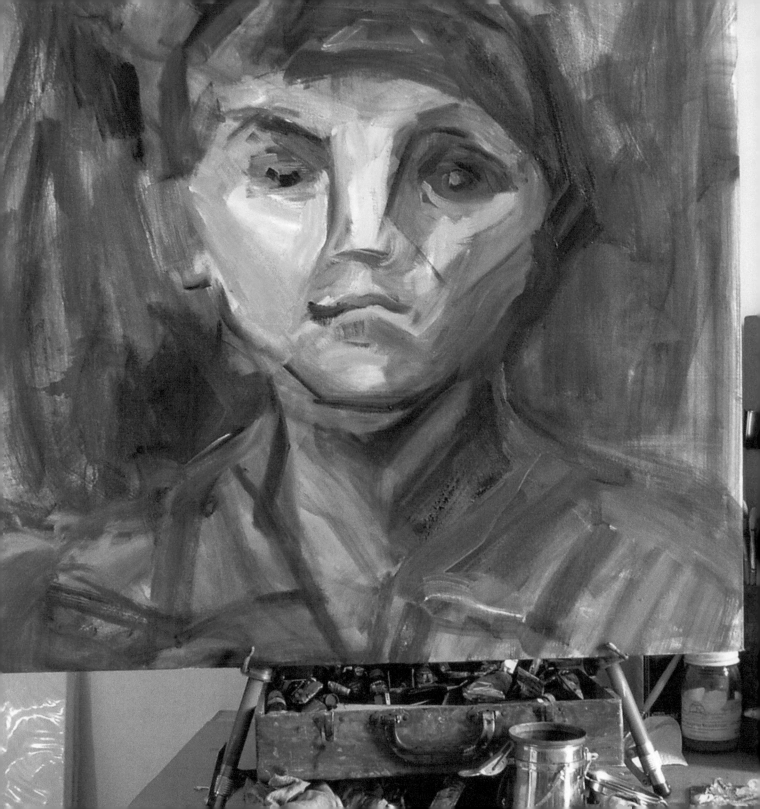

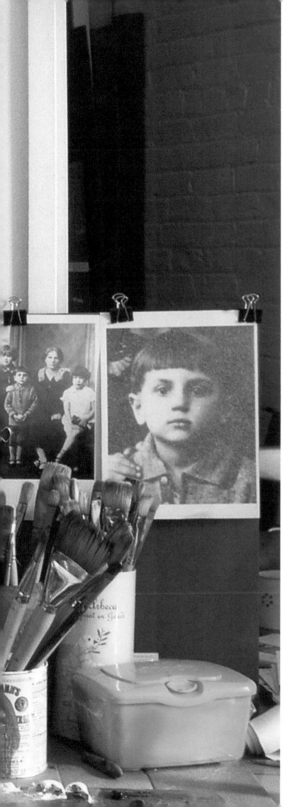

As a child, it is not possible to truly comprehend the atrocities of the fascists. It is hardly possible to understand it as an adult. But when you hear or see something over and over again, it becomes an echo in your mind, even when it is not in front of you. As flashes of my uncle's identity were revealed, the whole concept of identity became fascinating to me.

I began to understand the workings of people that try to destroy your identity. Every stereotype reduces your identity into one small aspect, making it easier to ignore your humanity. But in reality, that is just an insignificant part of the whole person. Kalman was not just a Jewish boy in a photograph. Kalman was not just my mother's long-lost brother. Kalman had an identity—a rich, vibrant one.

After my first few weeks in the factory, I heard that they took all the Jews out of the town and sent them to be gassed. They sent them to Chelmno—all the people from the town. No selection anymore.

So, I don't know if Kalman went along when he heard all the Jews are going to be transported, or if he remained there on the farm and for some reason got destroyed by somebody. I really don't know how he died. After the Liberation, I tried to look for him and I advertised in all the places. But I know for sure, that if he had been alive, somehow, we would have found each other. And we never did.

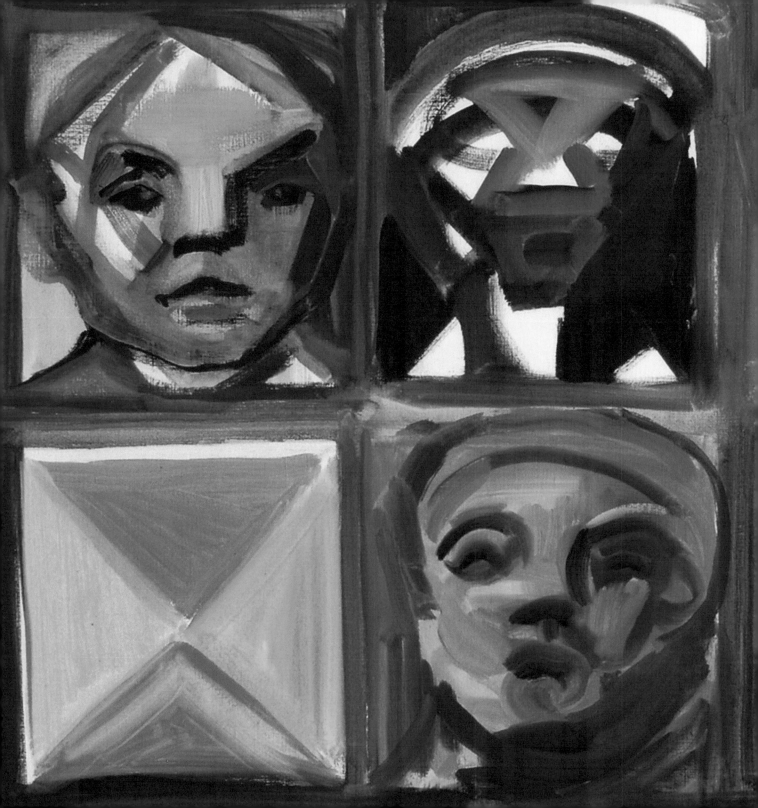

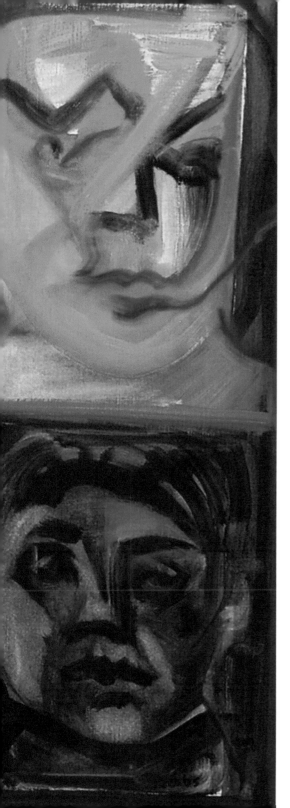

As a child I fantasized that I would find Kalman for my mother. I would bring a piece of her lost past back to her. I would be her hero.

I didn't know exactly what happened, but I knew there was something that needed to be repaired. It wasn't until I went to the Holocaust museum at Yad Vashem in Israel when I was 17 that I had a concrete picture of the horrors my mother had experienced. It was like a punch in the stomach, having all of those stories put together with all of the details she had shielded me from.

We lived in barracks and worked in the factory. My machine was at the end of a row. We had to control the empty shells to make them smooth. You had to stand 12 hours on your feet. Run the machines, call a mechanic to change parts to operate it. When it was finished, it went to a place where it was washed and then to a place where they put powder in. Where they put the powder in, the people turned yellow…very few survived and most were sick and couldn't have children…

I met your father in that factory. He came a year after I did and he worked on a machine near mine. I got to know him because one day his father had uncontrollable hiccups and a nurse said that a sugar injection, that would help him. I saw Daddy standing near my barracks and I walked over to him. He told me he needed some sugar and I knew a woman and I got it for him.

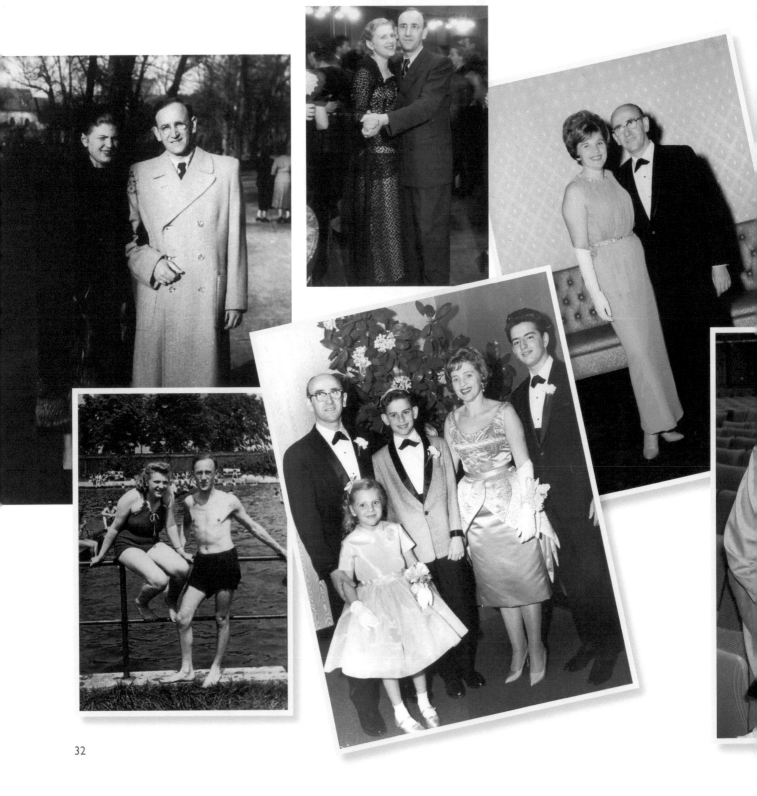

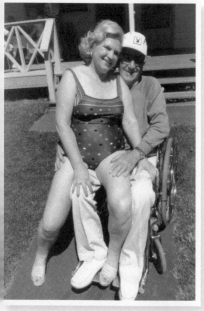

Surviving the Holocaust made my parents witnesses to a historic tragedy so monumental that we as citizens of the world are still trying to figure out what happened. The horrors are just too immense and even the survivors themselves find it incomprehensible.

As the witness to the witness, I am compelled to tell my parents' story, with them guiding me all the way. We ask ourselves what will happen when the last survivor is gone? Their stories are well documented, but the survivor who stands in front of an audience of children or adults and tells his or her story is the most compelling of all. It is one person's story that perhaps we can grasp—the murder of six million is too tragic to fathom.

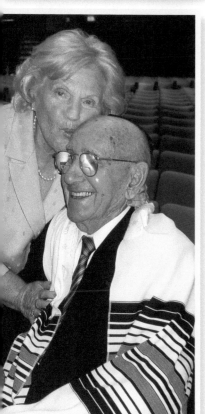

Little by little I got to know your father better. He would find out what was going on in the world from a Polish worker who would bring him a newspaper once in a while. He was always trying to get news. He was very optimistic and he encouraged us. "Don't worry, the war will end. We are going to survive." So everybody liked him. Girls were jealous because Jack came over to me. "I think you get your curiosity from Daddy."

Once, he came to the closet where we kept the coats and kissed me. I was embarrassed because I never had a kiss before…after that, I never went to that room again. I had a box next to my machine and I put my coat into the box. To me, if a boy kissed a girl, she got pregnant. I was a dummy when it came to those things.

But we liked each other and Jack and I decided that if we survived, we would try to meet after the war.

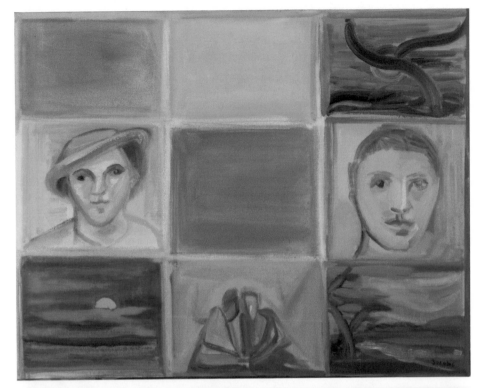

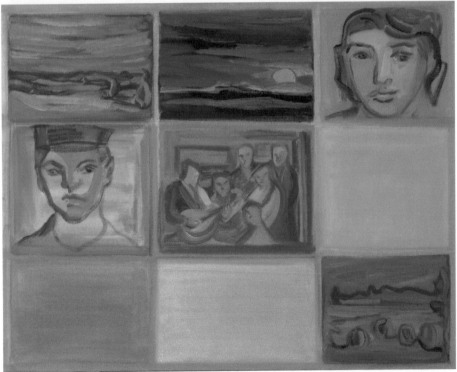

I never planned on painting anything connected to the Holocaust. I recorded my parents on audiotape, then videotape, and I wanted to share their stories in their words. When I wrote fiction and screenplays they were always on the subject of the Holocaust. But painting for me was another realm. I didn't see how to effectively share their stories through painting and I definitely didn't want to trivialize their story in any way.

Like many children of Holocaust survivors, I felt that my life had to have a purpose—had to matter—for all the others who were not alive. For me, the act of creating was an answer to so much destruction. In art, destruction takes on unique and transformative powers. Picasso talked about destroying the painting in order to create art.

After Liberation was one of the hardest times. We fled from the camp, but we had nowhere to go. There was nothing to eat. At least in the camp, we had a little food, even if it was terrible like cardboard. Jack left the camp before I did and got back to his hometown. After a few weeks, he sent a guy on a bicycle to get me and we rode for three days in the snow. I didn't have warm clothes. We were freezing and hungry, but we made it.

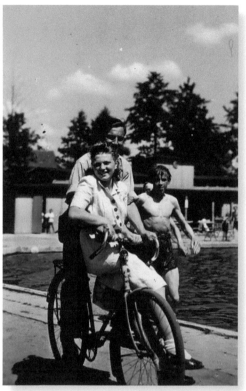

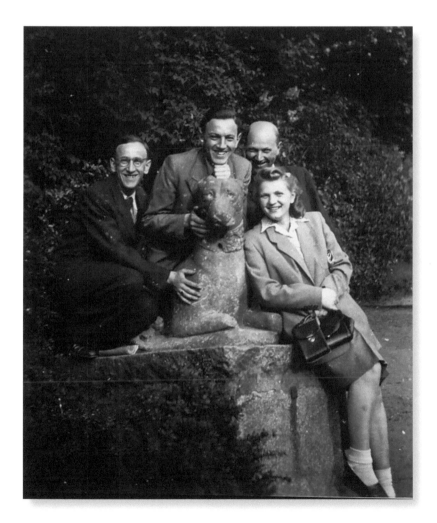

Jack had two brothers and a father who survived, so I right away came into a family after being so many years alone. Being a part of a family was one of the most important things…my husband called me "my orphan" (*meine yesoimeh*) with great affection. I felt good that being with him and his family, I was not an orphan anymore.

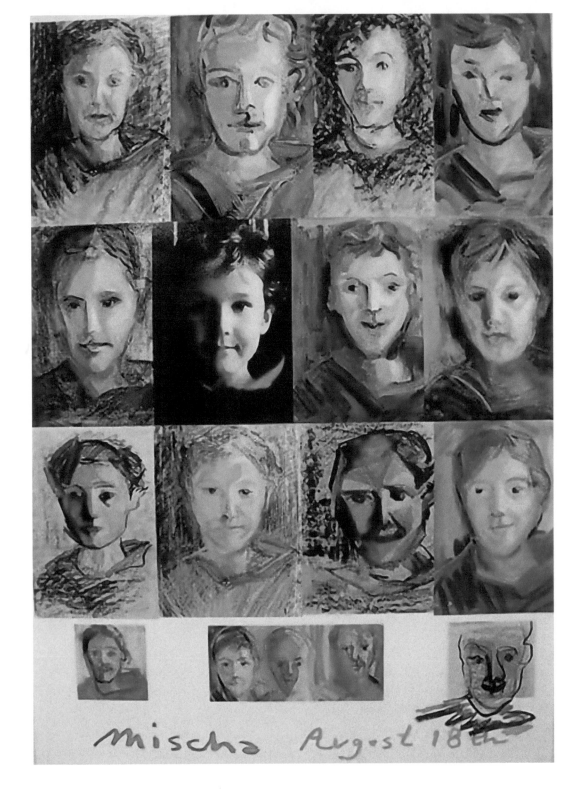

Mischa August 18th

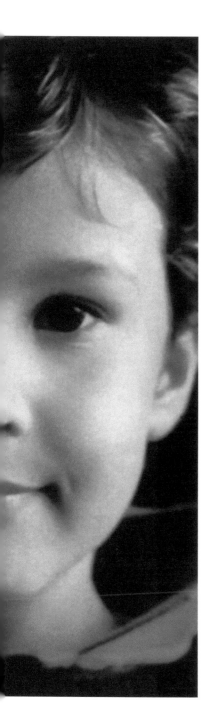

I had a friend, a young boy named Mischa, who died at the age of 22 because of a brain tumor that was first diagnosed when he was 13. His mother, who was also a daughter of a Holocaust survivor, sent an announcement with a photograph of Mischa that was taken when he was about 10, before any of the struggles began. His face was beautiful: smiling, innocent and intelligent. His mother's request was to send some memory, anecdote, or picture to honor him. I started painting Mischa's portrait and couldn't stop. I kept painting and painting until I had about 20 portraits. It was very intense and I felt him through this experience.

While I was painting Mischa and feeling him through the experience of painting over and over again, I realized that something in the repetition and attempt to capture him, made me feel connected to him and others in my own past, whom I had lost. Mischa's innocence and a certain dignified quality made him wise before his years and reminded me of Kalman. One boy lost to war and one to illness.

The worst day of my life was when I went back to my home city of Wloclawek and found out that no one in my family had survived. No one. I went to our apartment to see if I could find something, but the people who were living there wouldn't let me in. A neighbor did invite me in and she said I have something for you. Her son, Sigmund, had been a friend of my brother's. When the people who took over our apartment threw out our personal belongings, the boy had picked out a photograph of my brother and me from the garbage. He wanted to have a picture of his friend. She gave me that photo, which was the only picture of my family I had for a long time. I was happy to have it, but I couldn't wait to get out of that town. I felt like my feet were burning.

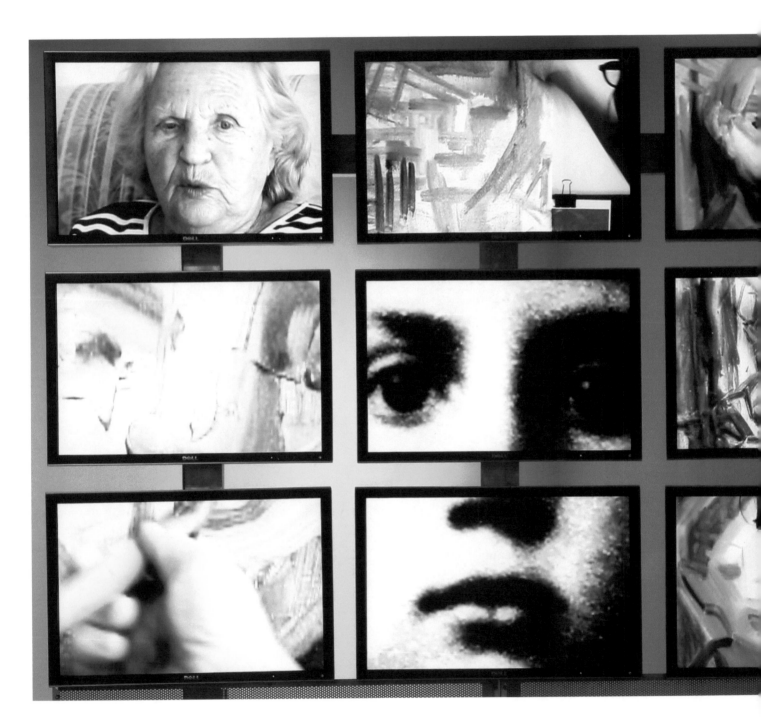

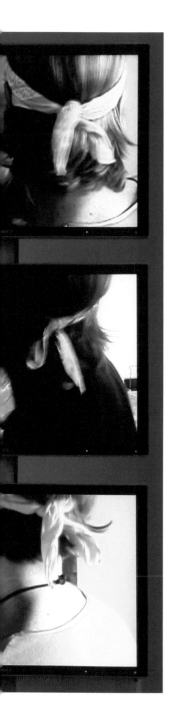

So many memories came back to me while I was working from Mischa's photo. During that period, I bolted up in bed one night and in what felt like a flash I saw how I wanted to share my mother's story. For a few years, I had been wanting to create a video installation that simulated the artist's experience of creating a painting. I planned to place the video next to the painting itself, so the video would show the process while the painting would show the end result. The viewer could then see the process and the end result simultaneously and have access to the creative process in a new way. I realized I could combine that idea with my desire to tell my parent's story and immediately the picture of Kalman came to mind. I envisioned nine video monitors and nine paintings of Kalman side by side-—together adding up to 18 elements. The number 18 represents *"chai"* or "life" in Hebrew. Fragments of memory—snippets collected through stories that my mother told. Memories and paint fractured and rebuilt. I knew I would call it The Memory Project.

We lived in Jack's hometown Wielun, which was a small town for a year or so, but we decided to leave because we didn't feel safe. We heard that Jews were getting killed. Then a friend of ours was murdered when he went back to the mill his family owned. We warned him not to go there, but he did and he was killed. We left there for Walbrzych (which the Germans had called Waldenburg). Then there was a pogrom in Kielce and 42 Jews were killed by a mob of people. So we decided to get out of Poland altogether. Even though we had a good business, we felt we had to leave.

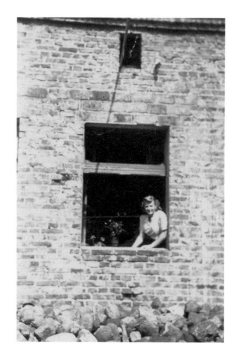

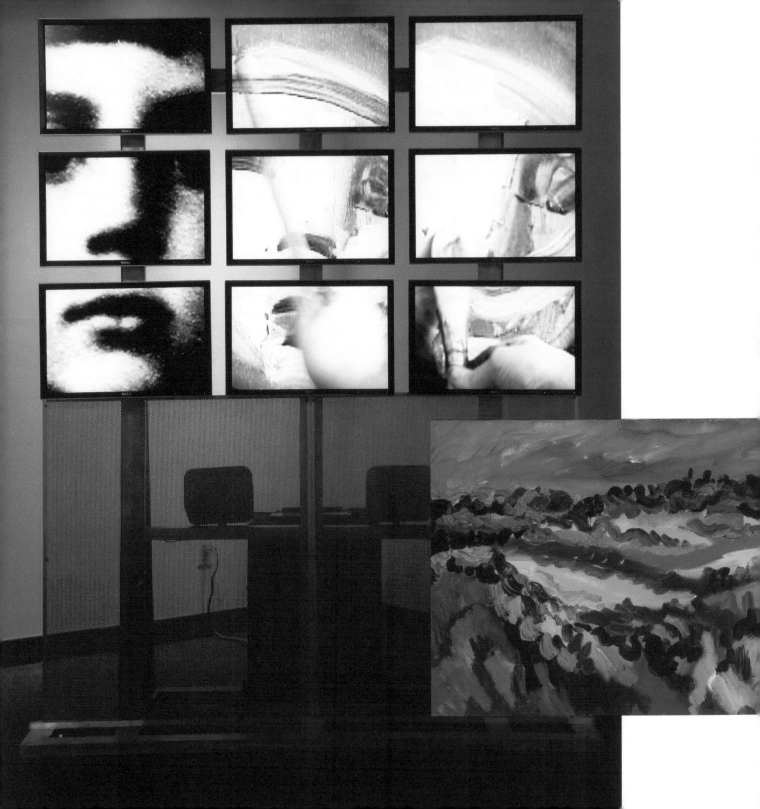

Out of observation, I felt something...a presence; I sensed something different each time I painted him. I felt a spontaneous side. I felt a sad side, a curious side, a dynamism.

A powerful thing happened when I was painting my uncle. As I was trying to find the movement of his head in space, painting the curves of his head and neck, I suddenly felt him looking up at the camera. In that moment, I actually felt like I was in the room, observing him. The gesture transported me to another time. I felt something really concrete in that moment, physically, emotionally. Kalman was speaking to me and I was listening.

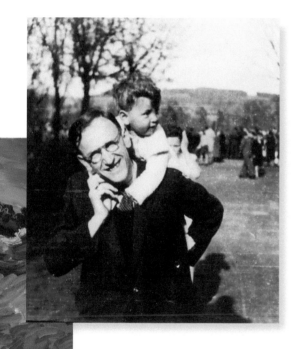

Daddy found a smuggler who would lead us over the mountains to Czechoslovakia and from there you could get into Germany legally. Daddy couldn't go because he had a little business and he had to sell off everything. I went with Daddy's brother Henry and with your brother Harold, who was only nine months old. ...we only had the clothes on our backs. We had to go through hills in the middle of the night when the guard was changing...we were like 10 people. Henry was carrying Harold. When I felt I couldn't go on, all of a sudden I saw my grandmother on top of this hill saying, "Come my child, come." A few days before I had a premonition, a dream of my grandmother on a hill...and when I saw her that night, it was the same hill from the dream. That's what got me over.

Daddy joined us months later. We went to Germany and there I had my second son, Fred. Daddy was making a nice living, selling things on the black market. We had a nurse for the children and we went to the opera and to the theater. I sat in Hitler's box in Munich and I thought to myself, "We won. Here we are sitting in his box. We survived. We're having families. He didn't succeed."

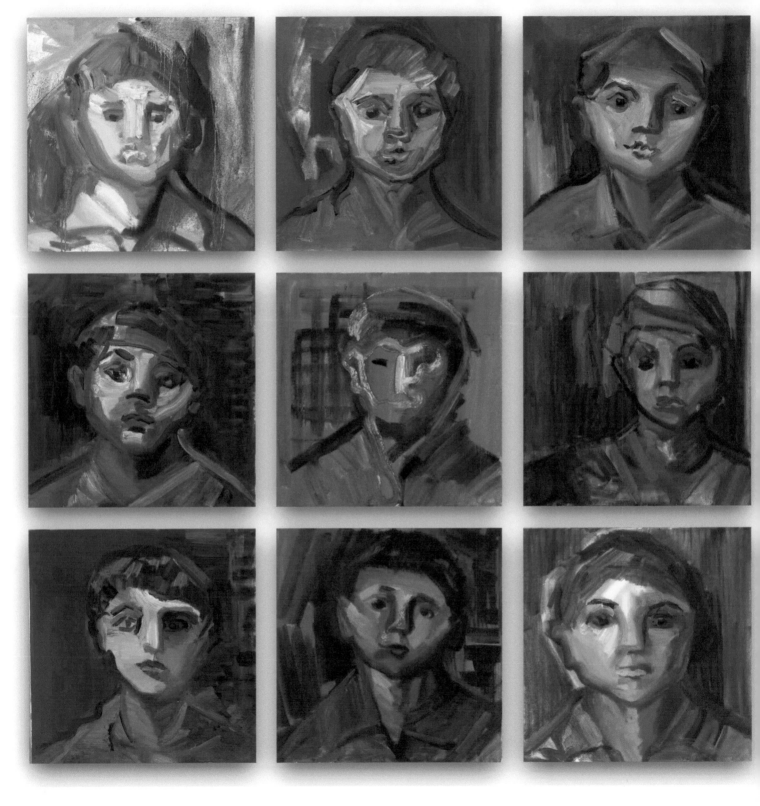

When the first nine Kalman portraits were done, we started editing the videotapes. It took my partner Laurie and me a full year to edit and a few months more to design and build the stands for the installation. It was plain luck that the first venue for the show was in Boca Raton, Florida, near where my parents and so many of their friends spend the winter. Both of my parents, my aunts and uncles, and many of their friends were able to attend. They loved seeing their stories told. Everyone had a story to add—about a brother, sister, or parent who'd been lost. I hope one day I'll have a chance to do justice to all of their stories in some way.

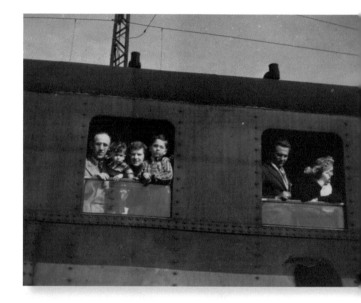

Even though we were comfortable, I hated living in Germany. I always was afraid when I heard German being spoken. We applied for papers to go to Australia and were all ready to move there. We even bought equipment to start a factory there, but then Daddy's brother Morris was rejected by Australia because of health reasons. The family was not going to be separated, so they sold the equipment and we started over and applied for papers to come to America. Roz was born here, in New York. At first, we all lived together, Daddy and his two brothers, Henry and Morris, Morris's wife, Stepha, and their daughters, Esther and Nancy. The men worked hard—six days a week, but there were no complaints. We were happy and we raised beautiful families and I'm so proud of all of our children.

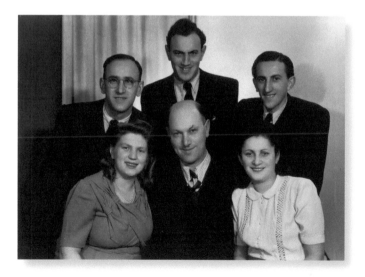

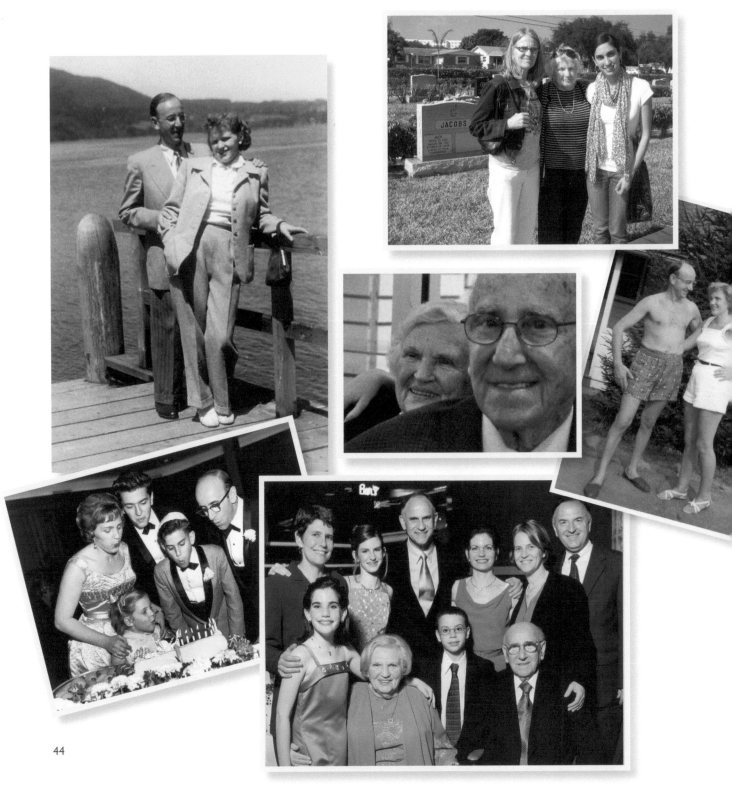

44

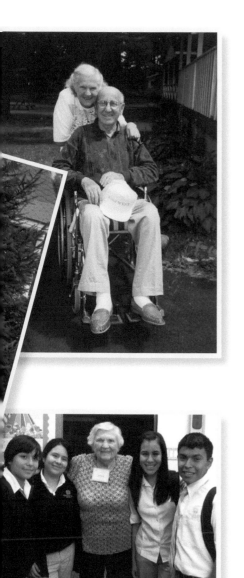

In America, my father worked and played hard, loved to dance and play cards. In 1969, I was with my mother when a phone call summoned us to the hospital. My father had been shot in the back during a robbery. I'll never forget the moment he said "I can't feel my legs" and the look between my mother and father. In the space between their eyes was a field of love so solid that nothing could break it. I saw that love is the most solid substance in the world. From then on, he was paralyzed from his waist down. My father became the best chair dancer around—leading the parade at Saturday night dances. Nothing could stop his spirit and my mother's love was intrinsic to that. He often said he had "a hard life but a good life." He was 87 when he died in 2008.

Jack was an optimist until the day he died. He believed that if people learn, there's a chance they won't repeat the mistakes of the past. If you asked me how I could go on without my Jack, I couldn't tell you. We were like bread and butter. I wouldn't move without him. But you have to go on.

I miss my husband terribly. I like to visit his stone at the cemetery. I talk to him. I have my kids and great-grandkids. They're all good people, educated people. That's our revenge against the Nazis—bringing good Jewish people into the world.

Now, I like to play cards with my friends and I see a lot of doctors—very educated people! I enjoy seeing what Roz and Laurie are doing with The Memory Project. I've gone to the schools with them and I like talking to the kids and the teachers. The kids come up to me at the end and want to hug me. All kinds of kids—black kids, Latin kids, Asian kids. Something in the story touches them and they touch me, too. I'm happy I can do it.

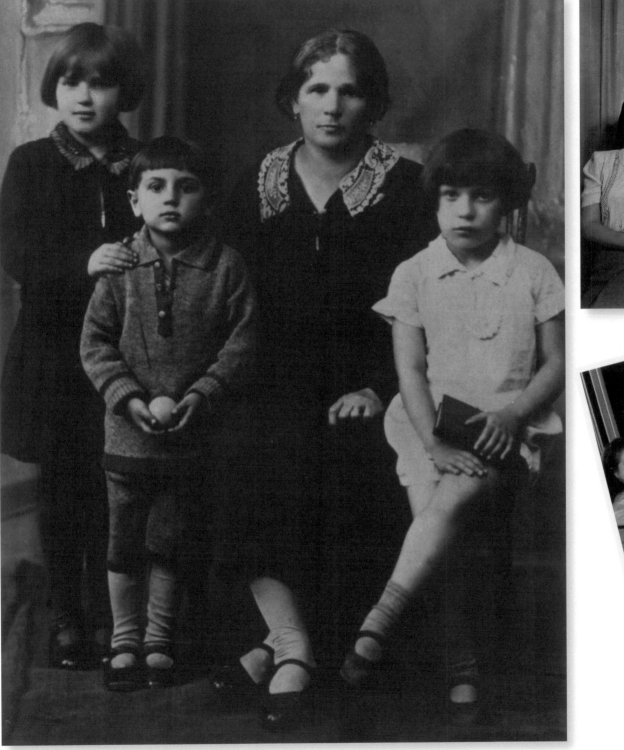
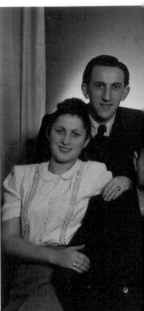

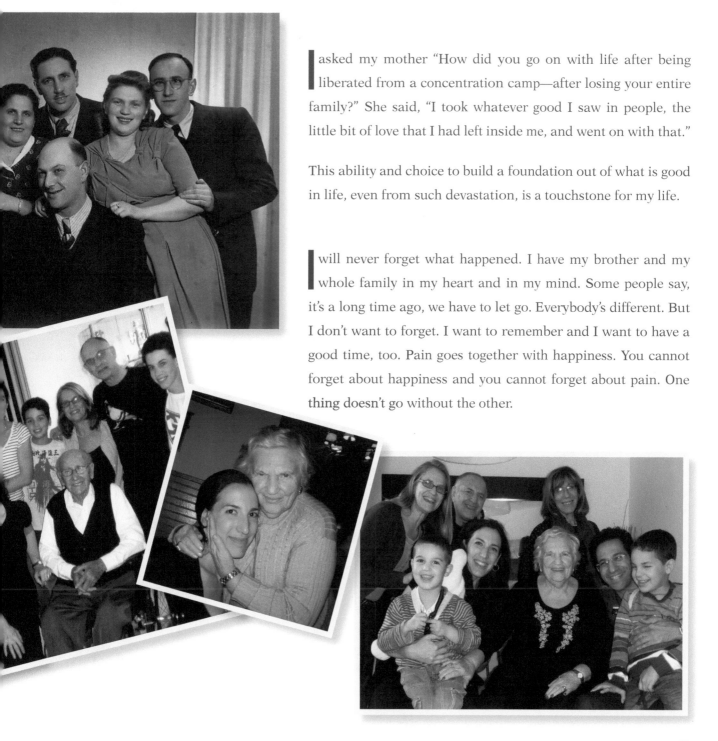

I asked my mother "How did you go on with life after being liberated from a concentration camp—after losing your entire family?" She said, "I took whatever good I saw in people, the little bit of love that I had left inside me, and went on with that."

This ability and choice to build a foundation out of what is good in life, even from such devastation, is a touchstone for my life.

I will never forget what happened. I have my brother and my whole family in my heart and in my mind. Some people say, it's a long time ago, we have to let go. Everybody's different. But I don't want to forget. I want to remember and I want to have a good time, too. Pain goes together with happiness. You cannot forget about happiness and you cannot forget about pain. One **thing doesn't** go without the other.

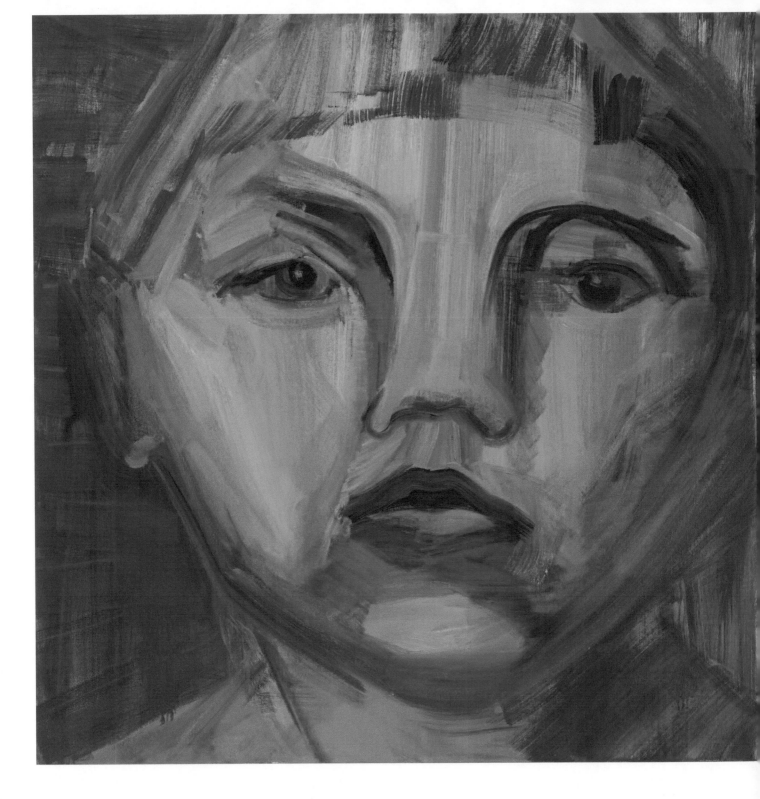

In the end, we have returned to the beginning, to an image that has transformed into a series of images, some static, some moving, all filled with memory. So many brushstrokes. So many colors. So many hours lost in observation. So many stories shared.

Painting Kalman repeatedly made me feel him alive, made me feel that his identity wasn't lost completely. The Nazis killed him and so many others. They tried to dehumanize them. But those who suffered and those who were killed are humans. Each one has a story. Thanks to my mother I can tell you a little bit about Kalman. And so, in some way, Kalman lives on for all of us.

After the inconceivable suffering of my parents and so many millions of people, we believed humanity would come to its senses. And yet we seem to eternally return to hatred, bigotry, and war. How do we combat those instincts instead of each other?

Our very existence means victory. After the war we were completely destroyed physically and emotionally. If we gave up then the Nazis would have won. But we didn't. As much as we would like to live happily ever after, life has ups and downs. What you make of it, that is what counts.

PHOTO CAPTIONS AND CREDITS, FINDING KALMAN

Cover: Detail, Huberman Family photo recovered from Uncle George Hubert after the war.

Introduction: Installation at the Houston Holocaust Museum.

p. 1 Roz Jacobs, courtesy of Ulla Kleienburg; p. 2-3 Roz painting "Family Portrait," courtesy of Laurie Weisman; p. 3 Huberman Family, l. to r Anna, Kalman, grandmother Esther, cousin Kayla taken circa 1931; p. 4 (clockwise from left) Jacobs family: Anna, her husband Jack, their children, Fred, Roz and Harold taken circa 1959. Roz at window. Roz on Bronx Street. Roz and Anna. Roz in bed; p. 5 Anna Jacobs, courtesy of Laurie Weisman, p. 6 "Kalman 13" by Roz Jacobs; p. 7 Anna's great-grandmother Devorah with granddaughter Zena Dinstock, courtesy of Eric Martins. Inset, Anna's older sister Henia and their mother Roisa; pp. 8-9 Roz painting "Anna and Kalman" in 2011, courtesy of Laurie Weisman. Inset, Anna and Kalman, circa 1935; p. 10 (clockwise from left) Roz with dictionary. Anna and Jack at a party with family and friends.Anna and Jack in a field in Germany with (from left) a friend, Jack's brother Henry, Anna and Jack. Harold and Anna Jacobs at the grave of Jack's father, Shmul Jakubowicz who died of a heart attack in 1949; p. 11 Jack and Roz Jacobs lighting Chanukah candles; p. 12 A wall was built in Warsaw to separate the Jewish side from the non-Jewish side. The Jewish side became the Warsaw ghetto, courtesy of USHMM; p. 13 (left) Starving children in the Warsaw ghetto. (right) Under Nazi rule, Jews had to wear badges

with yellow stars when they went out in public, both photos courtesy of USHMM; pp. 14–15 (left) Nazi rally. (right) Trolley car for Jews in the Warsaw ghetto, both photos courtesy of USHMM; p. 16 Paintbox and palette, courtesy of Roz Jacobs; p. 17 "Huberman Family Portrait" by Roz Jacobs; p. 18 Roz painting, courtesy of Laurie Weisman; p. 19 Esther Huberman; p. 20 "Jacobs Men" by Roz Jacobs (photograph by Jason Mandella); p. 21 (left) Detail of "Jacobs Men" by Roz Jacobs. (right) Jack, brother Morris, father Shmul and brother Henry Jacobs taken a few months after their mother Nacha, sister Rivkeh and younger brother Itzik were murdered circa 1939; p. 22, Roz in her teacher Norman Raeben's Carnegie Hall studio at age 21, courtesy of Irene Moshief Lerner; p. 23 Detail of "Family Portrait" by Roz Jacobs; p. 24 "Moonrise in Puycalvel" 2009 by Roz Jacobs (photograph by Jason Mandella); p. 26 "Artist and Model" by Roz Jacobs; p. 27 (left) Roz in Carnegie Hall studio circa 1976, courtesy of Irene Moshief Lerner. (right) "Gourdon Market, France" by Roz Jacobs; pp. 19–20 "Kalman portrait" by Roz Jacobs; pp. 20–21 "Kalman Grid" 2007 by Roz Jacobs; pp. 22–23 (clockwise from top left) Fred's Bar Mitzvah (Jack, Fred, Anna, Harold and Roz), Anna and Jack in Wielun, Germany circa 1946. Anna and Jack strolling in a park in Waldenburg, Germany, circa 1946. Anna and Jack relaxing at Paradise Village bungalow colony in the Catskills circa 1990. Anna and Jack dressed for a grandchild's Bar Mitzvah in Baltimore in 2005. Anna and Jack in New York in 1961. Anna and Jack in Germany circa 1948; p. 34, "Family Diptych" by Roz Jacobs; p. 36 (left) Shmul, Morris, Jack and Anna Jacobs in Germany circa 1947. (right) Anna on a bicycle with Henry Jacobs; p. 36 pastel portraits of Mischa Zimmerman by Roz

Jacobs 2006; p. 37 Mischa Zimmerman at about age 10, courtesy of Henia Drucker, pp. 38–39 (left) Memory Project art installation screen shot, photograph by J. Christopher. (right) Anna and a goat in Wielun circa 1947; p. 40 Memory Project art installation screen shot, photograph by J. Christopher, inset "Moonlit View" 2001 by Roz Jacobs; p. 41 Jack with Harold Jacobs on his back in Germany; p. 42 Kalman portraits by Roz Jacobs from Memory Project art installation; p. 43 (top) Emigrating to the United States: Jack, Fred, Harold and Anna Jacobs on the train from Munich to Bremerhaven where they took a ship to New York in 1951 (bottom) Jack, Henry and Morris and Anna, Shmul and Stepha (Morris' wife); p. 44–45 (clockwise from left) Anna and Jack in Matredwitz Germany, 1948. Roz, Anna and granddaughter Maya at Jack's grave in 2010. Anna and Jack at Paradise Village circa 2005. Anna with students from Cristo Rey Jesuit School in Houston 2011. Jack and Anna in the Catskills circa 1962. At granddaughter Naomi's Bat Mitzvah (from top left, Laurie, Naomi, Fred, his wife Karen, Roz, Harold, granddaughter Eva, Anna, grandson Reuben, Jack), Fred's Bar Mitzvah (from left, Anna, Harold, Fred, Jack, and Roz). Center photo: Anna and Jack at the opening of The Memory Project art exhibit in Boca Raton, 2007; pp. 46–47 (clockwise from left) Huberman family: Anna, Kalman, Esther and Kayla. Jacobs family after the war (clockwise from left) Stepha, Morris, aunt Henia, uncle Nathan, Anna, Jack, Shmul, and Henry Jacobs. Anna and great-grandson Itamar. Anna and granddaughter Libbie. Anna and Jack surrounded by children, grandchildren and great-grandchildren; p. 48 "Kalman 12" by Roz Jacobs. Back cover, Anna and Roz in Tel Aviv, courtesy of Laurie Weisman.

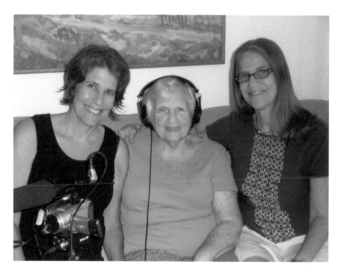

Laurie Weisman, Executive Director of The Memory Project Productions, with Anna and Roz

DEDICATION For mothers and daughters who have a story to tell.

For artists who tell their stories with music, paint and words.

For Kalman and the one and a half million Jewish children killed during the Holocaust who can't tell their own story, and for all those who have no one to tell it for them.

THANK YOU

To Sheila Sweeny Higginson who inspired and helped shape this book—a heartfelt thank you for your wise counsel at every word.

To our family and friends whose support is our foundation.

To our survivor community—we will keep telling your/our story.

To The Memory Project Productions friends and supporters—thank you for believing in our work.

To Kerry and Paige, to Jim and Teri whose steadfast support makes all the difference.

To Joan Greenfield, a brilliant designer and a joy to work with.

To Laurie for co-creating everything, for trying to make a difference in the world and building dreams together.

To Jack, father and husband who gave optimism a whole new meaning, whose spirit and intelligence continues to inspire us and who is a hero to four generations.

Finding Kalman is published by
 Abingdon Square Publishing Ltd.
 463 West Street, Suite G122
 New York, NY 10014 USA
 www.abingdonsquarepublishing.com

ISBN 978-0-9830762-2-3
Library of Congress Control Number: 2012934189
First Printing: March 2012
Printed in the United States of America

CPSIA information can be obtained
at www.ICGtesting.com
Printed in the USA
BVHW022351170319
542843BV00001B/1/P